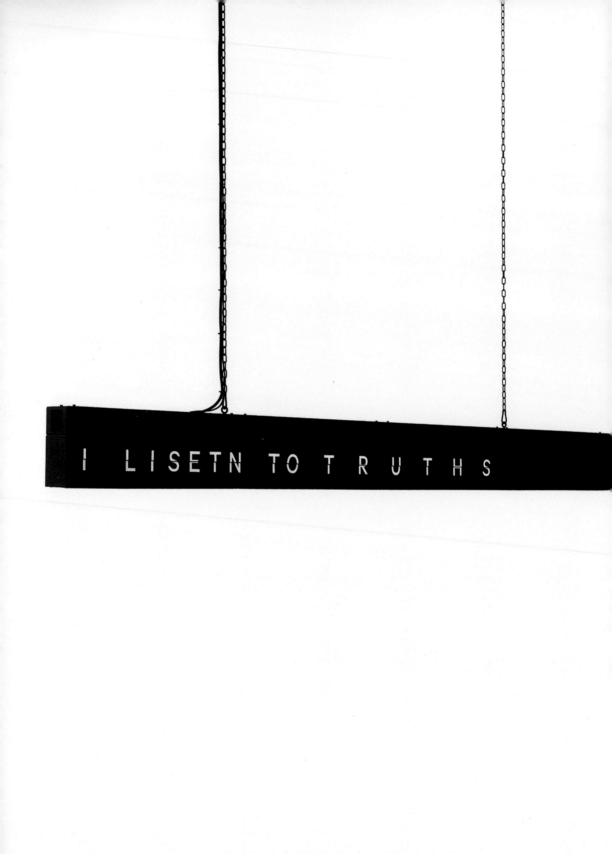

Shilpa Gupta
Sun at Night

Barbican
Ridinghouse

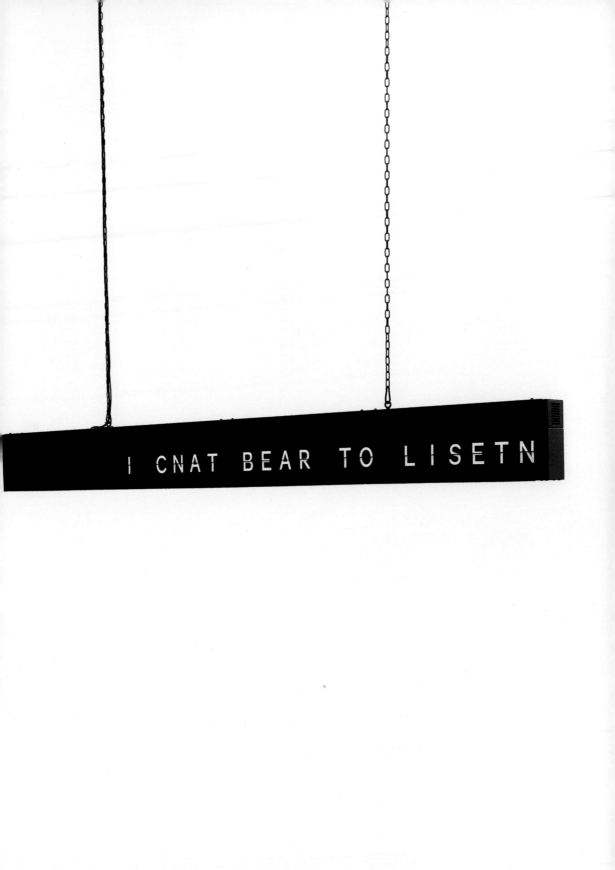

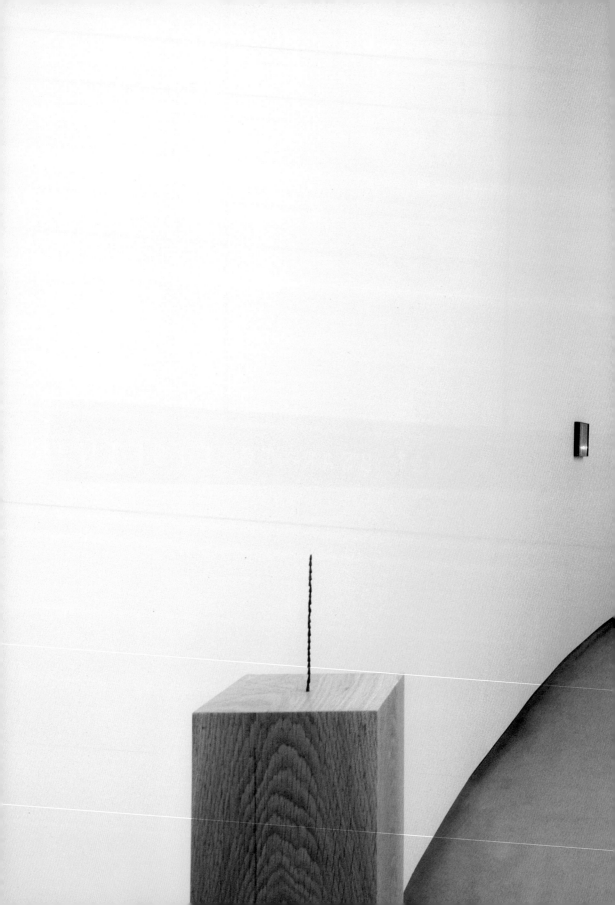

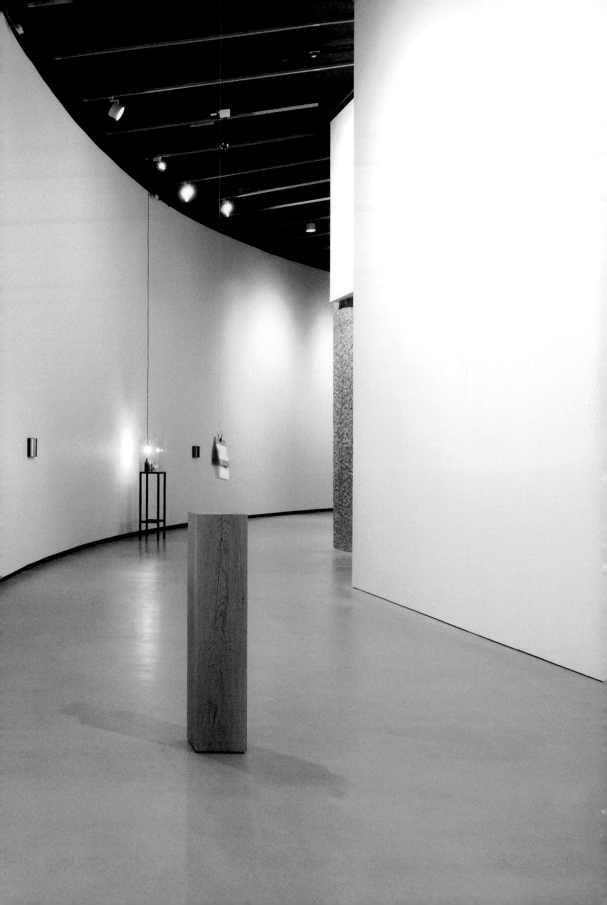

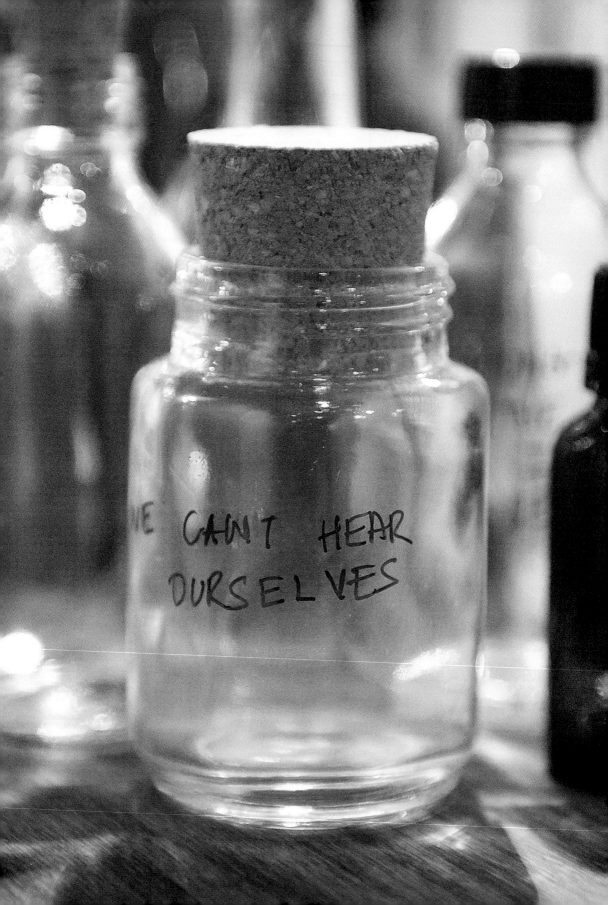

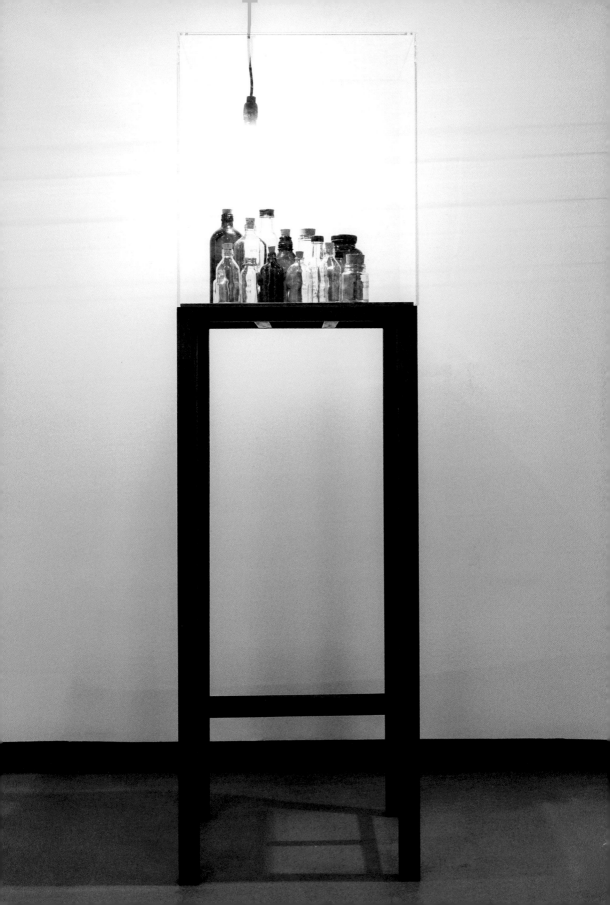

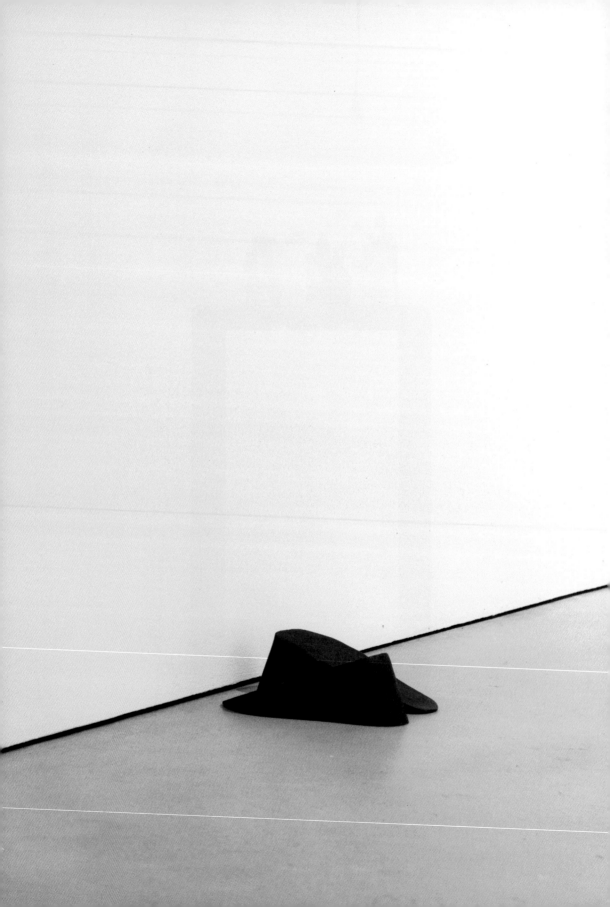

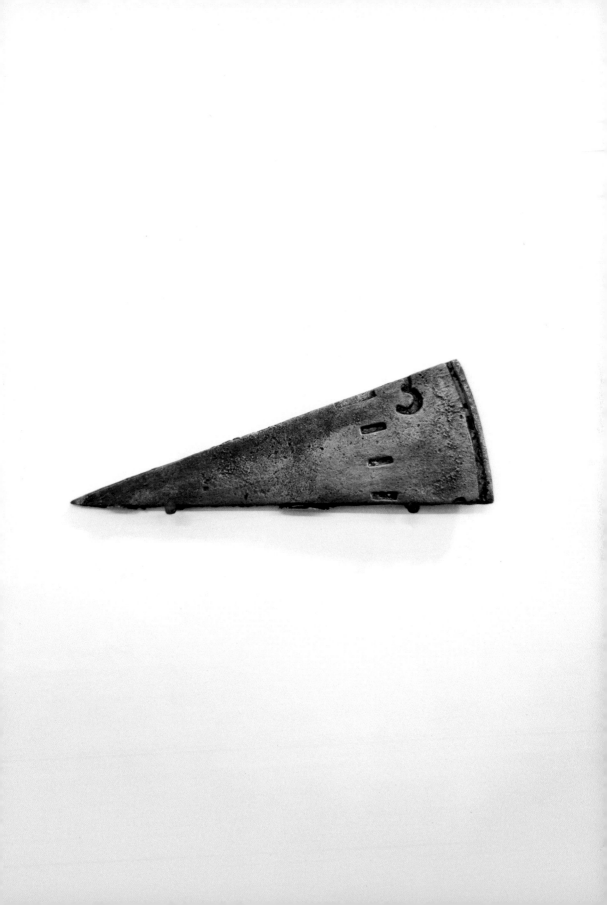

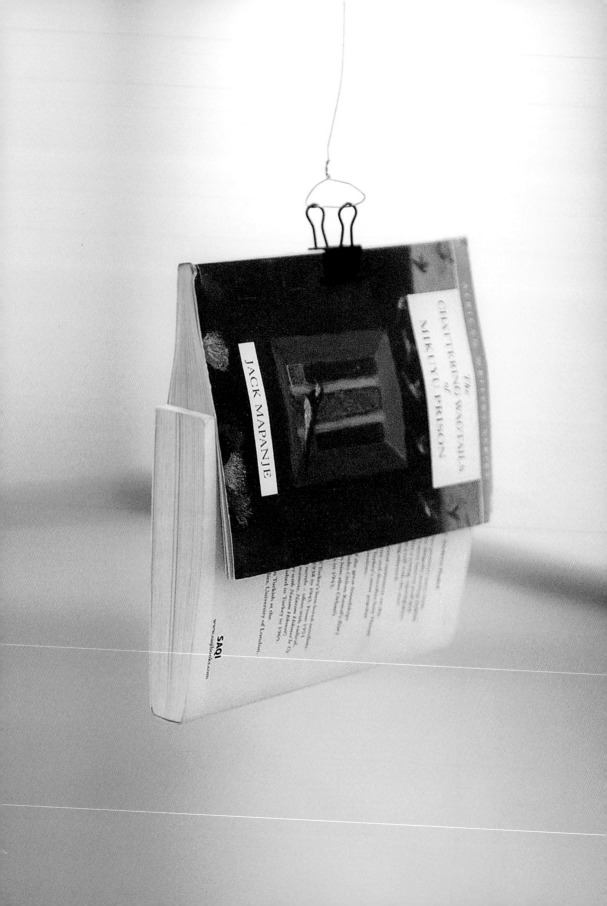

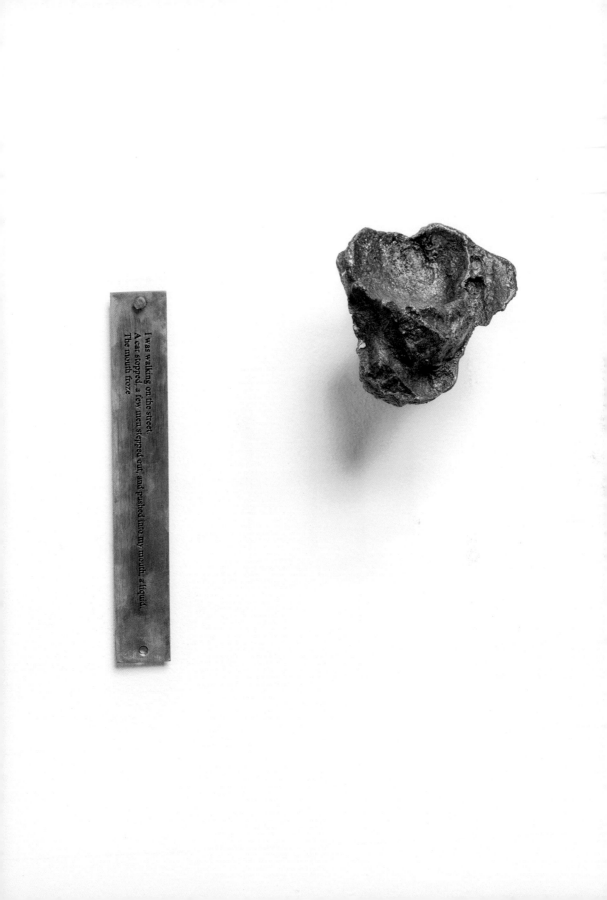

I was walking on the street,
A car stopped, a few men stepped out, and pushed into my mouth, a liquid,
The mouth froze.

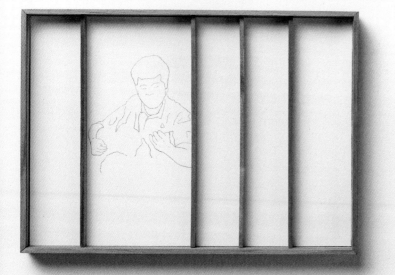

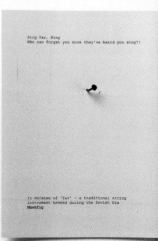

Sing Tar, Sing
Who can forget you once they've heard you sing?!

In defense of 'Tar' - a traditional string
instrument banned during the Soviet Era
Mushfig

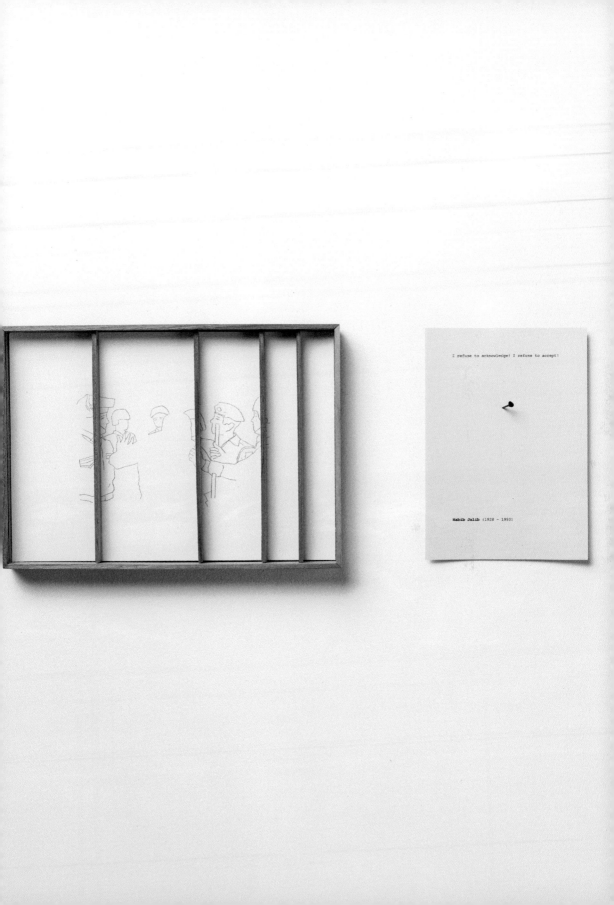

I refuse to acknowledge! I refuse to accept!

Habib Jalib (1928 - 1993)

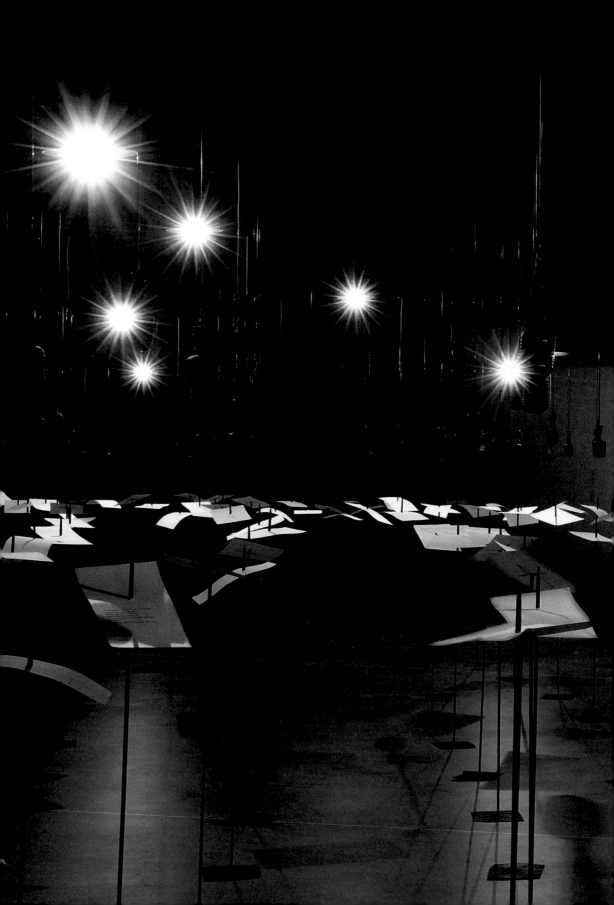

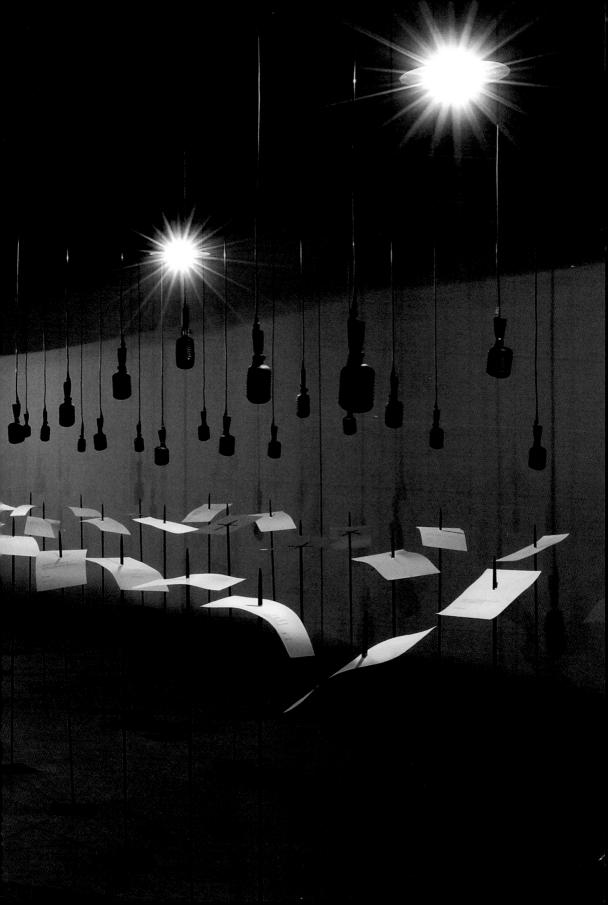

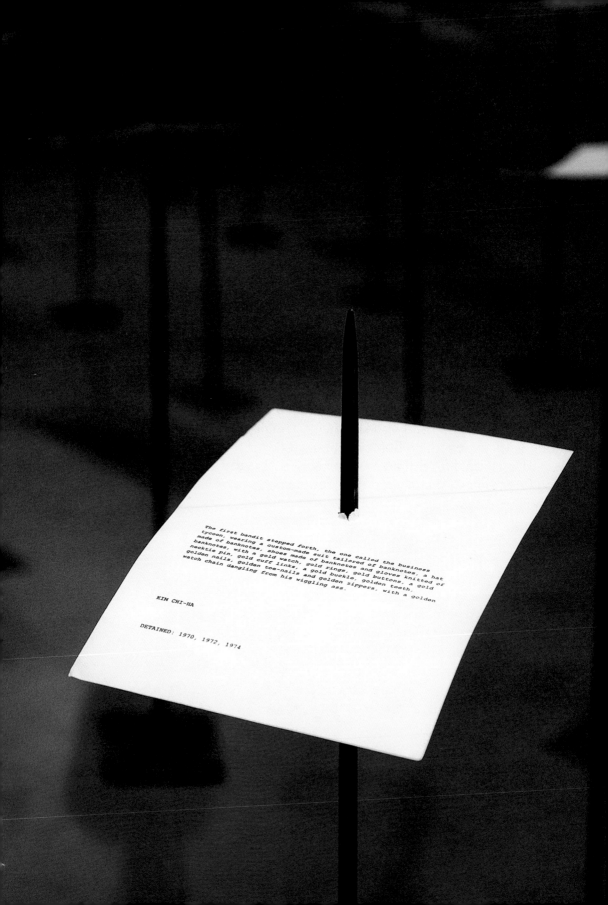

The first bandit stepped forth, the one called the business
tycoon, wearing a custom-made suit tailored of banknotes, a hat
made of banknotes, shoes made of banknotes and gloves knitted of
banknotes, with a gold watch, gold rings, gold buttons, a gold
necktie pin, gold cuff links, a gold buckle, golden teeth,
golden nails, golden toe-nails and golden zippers, with a golden
watch chain dangling from his wiggling ass.

KIM CHI-HA

DETAINED: 1970, 1972, 1974

If words can survive,
what use are prisons?
Urvashi Butalia

As I write this, isolated in my comfortable apartment in Delhi
in the killing heat of summer, several images from the world
'outside' make their way into my consciousness. Hundreds of
people, despair writ large on their faces, begging for air – for
oxygen. Bodies of the dead washing up on the shore of the
Ganges: the river that brings life. State governments arguing
about who they belong to: your bodies in our territory; clearly the
river respects no borders. Thousands of workers, poor, hungry,
jobless, making the long, arduous trek to their villages because
the city is no longer hospitable to them. Farmers – old, young,
men, women – sitting in protest for the seventh month on the
outskirts of the capital city, with more than a hundred of them
dead from exhaustion and hopelessness. The nation in shambles,
its fault lines exposed, its borders subverted.

 This is real life. But so much of this is also the stuff of
Shilpa Gupta's art: the oxygen that people need in order to
breathe is in the very air around them. The air where, as Gupta's
wonderful work *There is No Border Here* (2005–06, p.27)
reminds us, your sky impinges on mine and my clouds meld with
yours. Yet, here in India, it is over oxygen that state is fighting
state: 'your' oxygen and 'my' oxygen. The borders the workers
traverse, or within which they are held in employment, are the
artificially drawn administrative and corporate borders, beneath
and around which the village seeps into the city and the city into
the town as stories of love, loss and longing fill the air. And the
farmers are demanding to be allowed to cross the border into
the city, asking to be listened to by their elected representatives,
breaching those borders in ones and twos until the mighty state
takes drastic action and hems them in, nailing huge iron spikes
into the ground so that there is no entry and virtually no exit.

 If anything escapes, it is the voice: the sounds of protest,
the songs of courage, passion, hope. There are no borders here:
there are the iron spikes and there are the words. The words of
the Pakistani poet Faiz Ahmad Faiz (1911–1984) soar into the air

– 'Hum Dekhenge' (We Shall See) – sung here as a promise of a new dawn. They are shared on social media, they travel across borders, they go viral. And everywhere, people who listen to them are moved, perhaps by the melody or the sentiment or the courage, even if they do not understand the words. The iron spikes may have stopped food and water from reaching the protestors, but they cannot stop their words from reaching the world.

It is such realities that form the bedrock of Gupta's work: the everyday engagements of ordinary people with the super-structures that try to regulate and discipline, and how these are perceived and subverted. It is to these that she constantly returns. Her work is deeply political, although she prefers to use the term 'everyday', but to me it speaks of a politics so profound that it draws into its ambit all forms of power: that of the nation and its leaders, of borders, violence, patriarchy, history, memory, silence and so much more.

Even as the artist articulates the nuts and bolts of such power – as in the use of the yellow tape to demarcate off-limit areas, or the flag that speaks of the divisions of war beneath the connections of the sky, or in the border regulations between Bangladesh and India, or indeed in the rigid boundaries between India and Pakistan – she gently, quietly, almost as if by stealth, subverts these. If the fenced-off border between Bangladesh and India will not allow the easy crossing of people, a nexus of trade and profit creates a dynamic hidden market in all sorts of contraband, including medicines. If Indians and Pakistanis cannot meet physically in their countries, they exchange posters over the Internet, print them out and put them up on walls in their towns and cities.

If superstructures are the context against which Gupta's works find articulation, she is also deeply concerned with memory and history. How do we remember – or not – the past? How does it impinge on the present? What are the meanings of history? Does history lie in the line that marks a border between two countries, or in the stories that people carry with them as they travel across borders? Does it lie in the exercise of power by the state and rulers, or in the voices that those powers silence? How then do we listen to those silences? Borders and territories call up the idea of nations and nation-states and, through those, ideas of home, belonging and identity – which for Gupta are fluid and continually evolving, in direct contradiction to the attempts of power to contain them within given structures.

These questions resonate in so much of the artist's work and grow almost organically, as if they are part of the conversations the artist engages in with people she meets, those she talks with and listens to, and indeed as if they are conversations with the work she creates. Sometimes, the discourse is deceptively simple. In *National Highway No.1 (En Route Srinagar to Gulmarg)* (2005–06) Gupta travels from Srinagar in Indian-administered Kashmir to the tourist town of Gulmarg. She films the lush, green landscape of the valley. Soon the viewer notices, at regular intervals of barely a few hundred feet, the presence of heavily armed soldiers. This is how the nation – an idea supposedly born of a collective belonging – secures its borders and dissidence within them.

What is the precise moment at which an idea for a piece of work is born in the mind of the artist? Where and how can we trace its beginnings? Following one of her journeys from Bangladesh to India, Gupta purchased a jamdani from a local who had brought it across the border: an exquisite, delicately woven sari that is typical of the country that became Bangladesh. Taken apart thread by thread, this sari transforms in the hands of the artist into a minimalist ball of cotton that measures the exact length of the Indian-Bangladeshi border. Had the idea of the ultimate form of this work already taken root in Gupta's mind as she negotiated the purchase of the sari with its seller? Or was it a stray thought in the margins of her memory, to be recalled later? These questions recur every time one encounters her works. Each work connects with the one that has gone before and anticipates other associations with those that will come after.

The exploration of borders as they play out in people's lives finds echoes in other works. In *100 Hand Drawn Maps of My Country* (2008), the artist asks a hundred people to draw a map of their country from their imagination; the resulting images need no explanation. In *Someone Else – A library of 100 books written anonymously or under pseudonyms* (2011, pp.28–29), she explores what it means to become the 'other', to cross the borders of identity, or to lose that identity and simply be anonymous. In this way, too, her works converse with each other.

The recurring subjects that animate Gupta's work allow us to 'read' it somewhat like a continuous essay, where the questions connect the works to one another and become ever more complex. Who is the 'other' – the soldier caught in a trench, the smugglers crisscrossing the borders between different countries,

21

or the writer who becomes someone else in their choice of name? How does the border appear to those on either side of it, to those who manage to cross it, to those who leave it behind and go 'elsewhere', or to someone who may lie on the border's ground and look up at the sky where it does not exist?

It is an almost 'natural' step to go from finding expression through the owning of an 'other' identity to the silencing of those who dare to speak on their own. It is to this that Gupta moves in her work *For, In Your Tongue, I Cannot Fit* (2017–18, pp.16–18), which brings together the voices of a hundred poets from across the world who have been incarcerated for what they had written or said. The spare, dark room in which these stories find expression is like the absent space in history, alive with all the stories that did not get told, its very air somehow vibrant with the souls of the living and the dead. A hundred tall iron spikes – reminiscent, for me, of the spikes driven into the ground to hold the farmers in place, the intention defeated by the escape of their words – haphazardly hold pieces of paper that are inscribed with the imprisoned poets' words. Above the spikes hang a hundred silent microphones, at the ready to absorb the words held captive by the spikes. Intermittent hanging lights reflect off the polished hard floor. Slowly, sound begins to fill the air; a line is spoken by a single voice and echoed, repeated and joined by many others. The story of one melds with the stories of many, crossing the borders of time and space and challenging the powers that be. If words can survive, what use are prisons?

This powerful work is often characterised as a sound installation, but, like much of Gupta's work, it unfolds in text, sound, light and space. The poets here come from many places – Italy, France, Turkey, Azerbaijan, Persia, India, Pakistan, Bangladesh, Korea and more. They cut across vast swathes of time and they carry diverse experiences: of being imprisoned for writing about sex and sexuality, of being burnt at the stake for thoughts considered heretical, of the refusal to compromise or be silenced. The power of words against the might of the silencers lies at the heart of this work, traversing the borders of time and space in profoundly moving ways and creating, in the space that holds it, a worldwide history of brute power and courageous resistance.

Among the hundred poets, some ten or eleven are women. The smallness of this number is not insignificant, bringing to the fore a set of questions to do with deeper forms of silence. Did female poets and writers escape such persecution? Was their

speech not considered dangerous enough because it mainly inhabited a private or domestic sphere? Or was it that they were simply not listened to and therefore they did not count? Is the little that we have an indication of how much more there must have been, but also of how some histories have been more effectively erased? Here, we may have to find meanings not in the words that survive but in the silences that exist.

Silence is a major preoccupation for Gupta, which is why it becomes so important for her to work with sound, as sound is measured against silence. As you listen to a single voice, followed by a haunting chorus of others, it is the silence left behind that is so resonant with meaning, so filled with stories that cannot be told but exist, as George Eliot once said, in 'that roar which lies on the other side of silence'.[1] The poets whose works are included here span centuries, they span the world, they point to a range of issues, in a sense they build for us a connected history of courage and resistance, of interconnectedness and loneliness. They tell us that no matter where and no matter at what time in history, power has always feared the word, the writer, the poet.

I posed a question to Gupta: how did you choose *this* hundred? 'Data', she says, 'is often problematic. What sort of parameters do you set up that allow you to choose?' How, she asks, can you create 'objective criteria' to allow you to put together a work like this? And then there are the issues of representation and language, which also have to do with translatability and so much more. 'I had all these things in my head,' she says. 'I wanted to make sure we went beyond those most obvious. For example, I wanted to bring in the Azeri language even though I knew the challenge it would represent in terms of research and translation, and indeed recording long distance.'[2] Even a cursory examination of her pre-selection notes is a fascinating exercise in itself. The eventual seamless presentation hides a history of meticulous, painstaking work.

The memory of a conversation with the linguist, writer and thinker Noam Chomsky led Gupta to a related aspect of this work. Chomsky spoke about how surveys and studies reveal that most people want peace and yet, when it comes to being heard, it is only the shrill voices of the dominant few – who claim the right to the word and to speak on behalf of others – that are given importance. 'This is why I wanted to build a chorus of 99 voices, those of the multitude, who echo the voices of the imprisoned poets. These voices come from within the underbelly of society', Gupta says.

23

The sounds of the multitude that animate this work are also what Gupta lives with every day in her home city of Mumbai. 'Every time I board a local train at Churchgate,' she says, 'I experience this intense sensation of being accosted, being surrounded by a multiplicity of voices and languages. I may not understand what is being said and yet, almost as if by osmosis, you somehow become part of an overwhelming mass of humanity, of dialects and languages.' It is this sense that she wanted to evoke in her installation, where, 'as you enter, you are surrounded by multiple languages and scripts, and not knowing becomes a part of knowing.'

Gupta's work grows out of conversations about the everyday and the ordinary, takes its inspiration from the sea of languages that flows around the artist near her home, and questions issues surrounding nation, identity and home. I ask Gupta the question that has been at the back of my mind ever since I began looking at her art: is the art gallery the best space for a work that addresses such questions? Should these conversations not take place elsewhere? 'This', she tells me with honesty,

> has remained an unsettled question for me. I've tried to create works that are participative and where audiences can take away pieces, but, yes, there are still unanswered questions. Sometimes it's a question of infrastructure, at other times the medium. The No Border Here tapes, for example, were hand-carried in my bag to Cuba, while the artworks in Aar Paar [the cross-border India-Pakistan project, 2002–06] were exchanged digitally across our tense borders and then printed out locally and pasted on street walls.

She points to this as a 'fluid mode of exchange, where artist friends become key players'. It was this that 'helped me to mount the large-scale exhibition Crossovers and Rewrites: Borders Over Asia at the World Social Forum in Porto Alegre, Brazil (2005)'.

Much of Gupta's work involves the use of technology to create interactive spaces. Sometimes, she says, 'the medium can surprise you with high costs. One needs to work with technicians to find ways around this, trying to keep equipment compact and lightweight.' She cites the work Speaking Wall (2009–10) to illustrate this. At other times she may need to 'find some local jugaad' (a form of makeshift arrangement), as she did with the

interactive *Shadow Video Projections* (2006–07), where she used a cheap camera, fairy lights and rolls of stitched-up shower curtains sourced from her local Crawford market: 'This made it possible for me to show this rather large-scale work in a simple tent in the street not far from where I live.'

We come back to this question a few days later. Clearly the problem of taking art to larger audiences is one that concerns Gupta deeply, and she speaks to my question by pointing out how art galleries struggle to draw in more people. 'Here, in South Asia,' she says, 'it's that much more difficult because the state is so indifferent to art, and private galleries have limited resources.' But public institutions – she cites the Barbican's Curve gallery, where entry is free – do draw in reasonable numbers of people, as do city biennales such as Kochi and Venice.

> Not every artist gets the opportunity to be shown in such a public context that draws in thousands of people. Yes, there are more economically viable forms like cinema, but the idea of the 'public' is, I think, more complex than the mere counting of numbers. Perhaps the only adequate response is to continue to engage, to take your art not just to a gallery or a public institution but wherever you can. I've tried to do this by pasting posters in streets, taking my work into trains, chasing the municipality for months to get permission to install my work in neighbourhoods and, most recently, experimenting with the making of a book with poems from the installation and the stories that don't leave me. I know that this isn't an easy road to negotiate, but I must continue to walk upon it.

As I close this piece, the farmers are still gathered at the borders of Delhi. The monsoon has set in and thunderstorms lower the temperature and flood the streets. And yet new groups of supporters arrive every day to join the protestors. They will negotiate the iron spikes that have been nailed into the ground to hem in the farmers and, adding their voices to those of the others, they will tell stories and songs and recite poems that will escape the spikes, out into the streets and fields – an inspiration for generations of protestors yet to be born, their inheritance and their legacy.

1 George Eliot, *Middlemarch*, Oxford University Press, Oxford, 2008, p.182.
2 Conversation with the artist, 5 June 2021.

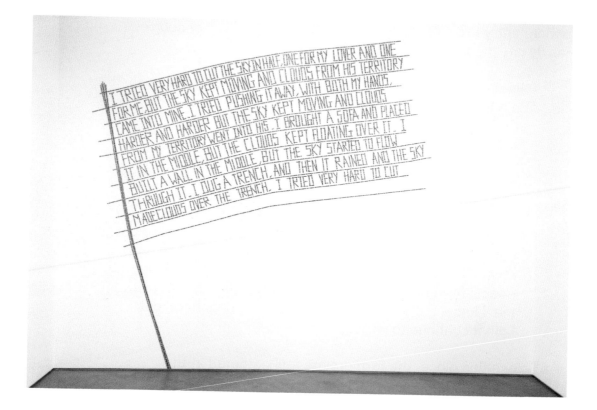

I TRIED VERY HARD TO CUT THE SKY IN HALF, ONE FOR MY LOVER AND ONE
FOR ME, BUT THE SKY KEPT MOVING AND CLOUDS FROM HIS TERRITORY
CAME INTO MINE. I TRIED PUSHING IT AWAY, WITH BOTH MY HANDS,
HARDER AND HARDER BUT THE SKY KEPT MOVING AND CLOUDS
FROM MY TERRITORY WENT INTO HIS. I BROUGHT A SOFA AND PLACED
IT IN THE MIDDLE, BUT THE CLOUDS KEPT FLOATING OVER IT. I
BUILT A WALL IN THE MIDDLE, BUT THE SKY STARTED TO FLOW
THROUGH IT. I DUG A TRENCH, AND THEN IT RAINED AND THE SKY
MADE CLOUDS OVER THE TRENCH. I TRIED VERY HARD TO CUT

26

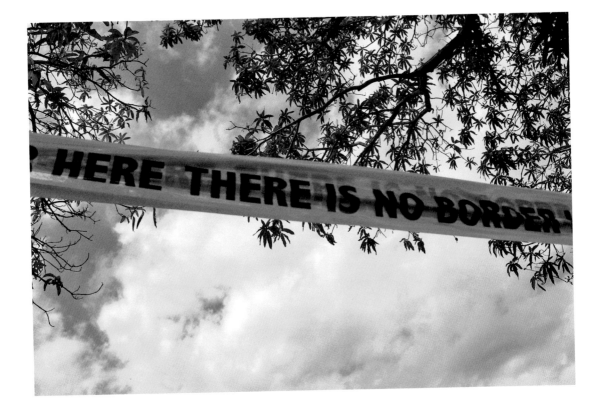

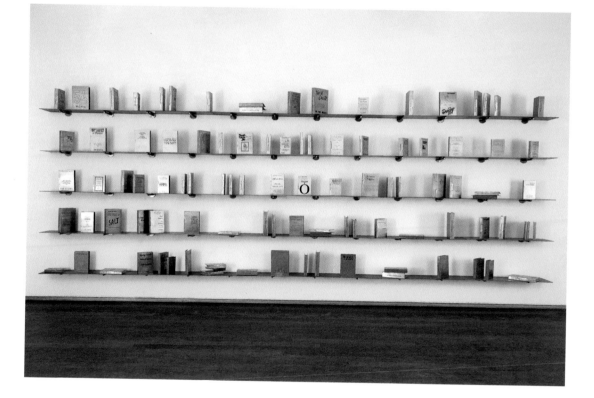

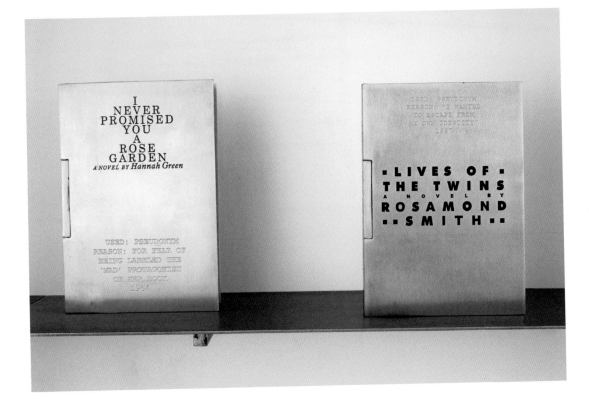

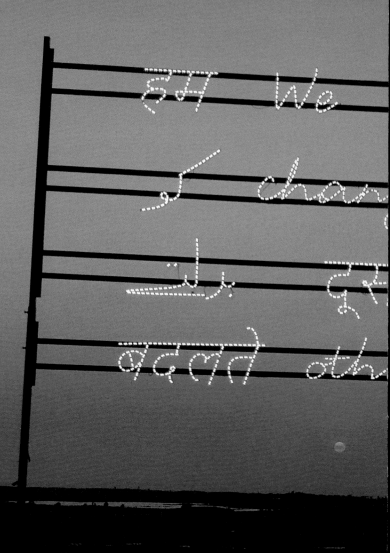

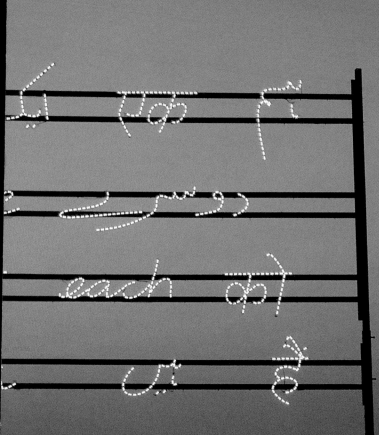

Hover, echo, persist
Shilpa Gupta in conversation with Hilary Floe

HF *For, In Your Tongue, I Cannot Fit* (2017–18, pp.16–18) is a truly extraordinary work that brings together a hundred fragments of poetic text, representing a hundred narratives of censored speech. Coming from across the globe, these were written between the 8th and the 21st centuries. In a space dimly lit by bare light bulbs, the viewer encounters a forest of spikes as suspended microphones raise a chorus of lament and protest, in defiance of past silences. The research process must have been a labour of love. What can you tell us about the genesis and development of this installation?

SG I have always been interested in the act of inter-pretation – of bodies, objects and ideas – and the relationship it bears with its environment. When systems map and tabulate to seek control, people masquerade, infiltrate and catapult! This particular work, though, is linked to a project I had started working on during 2009 named *Someone Else – A library of 100 books written anonymously or under pseudonyms* (pp.28–29). It's based around writers who wrote under a fictitious name and sought freedom in being 'someone else', whether to conceal their gender, avoid personal or political persecution, or even to publish a rejected work.

I hadn't known that some of the writers I followed – say George Orwell, or even one of my favourite writers, Premchand – had resorted to using fake names. I hadn't known that Premchand's books were burnt and that he was once charged with 'sedition' – a word that I thought had gone out of usage, until we started hearing it again recently. I came across the Turkish writer Aziz Nesin, who had challenged the right wing and their violence against him, and learnt that Voltaire had spent time in prison.

As usual, questions led to some answers and then to further questions. I started looking at the moments when words caused such discomfort to those who sought to restrict imagination through the mobility of a writer. This, along with the increasingly restrictive atmosphere under the current government in India, led to my interest in the power of words and the nervousness felt towards them by those in power. Poets, like writers and artists, are dreamers who even speak of nightmares of the living world. The work is about the persistence of beliefs, of dreams, which make us what we are as individuals.

HF Originally commissioned for Edinburgh Art Festival and YARAT Contemporary Art Space in 2018, *For, In Your Tongue, I Cannot Fit* has since been shown by a number of institutions around

the world. Upon first visiting the Curve you felt strongly that it would work well here. The 90-metre-long gallery wraps around the back of the Barbican's concert hall as a kind of poetic and spatial inversion. What was it about this space, or the context of the Barbican Centre, that resonated for you?

SG It was an honour to receive an invitation to show this sound work at the Curve. It's long and narrow with exceptionally high ceilings. Somewhat cavernous, the Curve snakes behind the large theatre like an unexpected hidden corridor, similar to a footnote or perhaps the spine of a curled-up creature. Your proposition to show *For, In Your Tongue, I Cannot Fit* in the Curve made sense–to infuse the space with voices and sounds that hover, echo and persist through the being of our societies.

HF Over the course of planning this exhibition together, the world has been radically altered by the Covid-19 pandemic. Originally scheduled for autumn 2020, we are now opening in autumn 2021. It's been a time of rapid change, loss and social division. Given your fascination with boundaries and thresholds, what has this period been like for you as an artist and an observer? Has it made its way into your new works?

SG The past 18 months have been unpredictable, and a lot of us have been in confined spaces and in a state of constant uncertainty. Some of these experiences seeped into a series of small works I made early this year, for example a set of feet facing the wall as though caught in a state of immobility (p.10). This work has made its way into the Barbican show, along with *Distance Between Two Tears* (2021, p.3), which is about stillness and an aftermath. I also recently finished a work that was left incomplete just before my studio closed in March last year. It's a small piece about expectations around a compressed time: the visitors' hours in a prison (p.11). It's strange – the space where my works were before, through and after the continuous lockdowns seems to have blurred.

HF Do you think post-pandemic audiences will respond differently to *For, In Your Tongue, I Cannot Fit*? Although on a very different scale, this last year has been one of confinement, anxiety and isolation for so many of us, and it has certainly made me think more deeply about the much more extreme experience of imprisonment.

SG Rarely have so many streets been so silent across the world. People sat huddled in their homes not knowing whom to believe and what to expect next, attempting to make sense of the external

intrusion that had suddenly taken over their lives. Yes, you're right, it's very much like in the case of many poets who were suddenly and unexpectedly imprisoned. Unlike us, though, they were forcibly separated from their families, lived in harsh environments, detained without trials and exiled from the places they loved deeply. Perhaps a post-pandemic audience might relate a little more to this state of confinement and the sense of waiting endlessly.

HF You've incorporated language into many of your works throughout your career, from the *Eye Test* series to your split-flap boards (pp.4–5), which you've been developing since 2008. You often deliberately build in a fractured or thwarted quality to these communications, with misspellings or typographic oddities, for example. Even in the Curve installation you've talked about the importance of using multiple languages, so that visitors experience a mixture of the comprehensible and the incomprehensible. What draws you to use language in this way?

SG I'm intrigued by the way we construct and remember the world, and therefore by agency – which is where the play of language enters, be it via the forms that we fill in when someone is born or leaves us, or the news we read, or when we

want to make a transaction or move from one place to another. The language around us reaches us after scripting, editing, slippages and erasures. In fact, the language that makes it into written form might be just one of many languages that are spoken. For example, both Hindi and Urdu were contenders for being the national official language in India in the 1940s, but neither are spoken by a large enough part of the population. While certain figures make their way into our myths, bedtime tales, history books and parliamentary registers, there are others that are left out. Every time something is spoken, something else is left out. I'm drawn to the silences, which can sometimes contain even more than what is said. There's so much to learn behind this seemingly everyday form that is so easily normalised and taken for granted through repetition.

Из той земли, которой больше нет

ИРИНА РАТУШИНСКАЯ

ЗАКЛЮЧЕН ПОД СТРАЖУ В: 1981, 1982

39

For young boys, the girls I've left behind
And for old wine put clear water out of mind

How can you compare some bitch
who goes in heat once a month
and drops a litter once a year
with him I desire?
I reveal to him all my thoughts
Without fear of the imam or the muezin.

ABU NUWAS

DETAINED: 8TH CEN

قاوم يا شعبي قاومهم

ضمّت جراحي ونفثت همومي لله

فعلي ، فعلي نادى من قبره

قاوم يا شعبي قاومهم

دارين طاطور

معتقل : 2015

Mother why didn't you give me birth in the form of a skeleton

MALAY ROY CHOUDHURY

DETAINED: 1964

Məndə sığar iki cahan, mən bu cahana sığmazam,
Gövhəri-laməkan mənəm, kövnü məkana sığmazam.

Çək dilinivu əbsəm ol mən bu lisanə sığmazam.

NƏSİMİ

HƏBS OLUNDUĞU IL· 15TH CEN

43

Then, proudly let our banner wave,
Wi' freedom's emblem o'er it,
An' toasted be the Stockport lads,
The lads who bravely bore it.
An' let the "war-worn" Yeomanry
Go curse their sad disasters,
An' count, in rueful agony
Their bruises an' their plasters.

SAMUEL BAMFORD

DETAINED: 1819

List of Works

Published in 2021
by Ridinghouse and Barbican

on the occasion of
Shilpa Gupta: Sun at Night
7 October 2021–6 February 2022

The Curve
Barbican Centre
Silk Street
London EC2Y 8DS
United Kingdom
barbican.org.uk

Head of Visual Arts: Jane Alison
Assistant Curator: Hilary Floe
Assistant Curator: Chris Bayley
Curatorial Trainee:
Tobi Alexandra Falade

Ridinghouse
46 Lexington Street
London W1F 0LP
United Kingdom
ridinghouse.co.uk

Publisher: Sophie Kullmann
Senior Editor: Aimee Selby

Distributed in the UK, Europe and
the rest of the world by
ACC Art Books
Sandy Lane, Old Martlesham
Woodbridge, Suffolk IP12 4SD
accartbooks.com

Distributed in the United States
and Canada by
ARTBOOK | D.A.P.
75 Broad Street, Suite 630
New York, New York 10004
artbook.com

Images © Shilpa Gupta. Courtesy of the
artist and Frith Street Gallery, London
Texts © the authors
'Speak' by Faiz Ahmad Faiz
courtesy Faiz Foundation Trust,
translation by Victor G Kiernan
Official copyright for the book
© Barbican and Ridinghouse, 2021

Edited by Chris Bayley and Hilary Floe
Copyedited by Daniel Griffiths
Proofread by Aimee Selby
Designed and produced by Zak Group
Set in Folio BT
Printed in Belgium by Graphius

British Library Cataloguing-in-
Publication Data: A full catalogue
record of this book is available from
the British Library.

ISBN 978 1 909932 65 4

Great care has been taken to identify
all image copyright holders correctly.
In cases of errors or omissions please
contact the publisher so that we can
make corrections in future editions.

Acknowledgements

Special thanks to Shilpa Gupta, as well as Frith Street Gallery, London; Vadehra Gallery, New Delhi; and Galleria Continua, San Gimignano, Beijing, Les Moulins, Havana, Rome, São Paulo and Paris.

We would also like to thank Ann Berni, Lucy Burnett, Sorcha Carey, Malay Roy Choudhury, Jane Connarty, Valentina Costa, Katrina Crookall, Marie-Fleur Dijk, Gwen Ellis, Kate Fanning, Harriet Findlay, Freddie Todd Fordham, Peet Gardner, Emelia Gatley, Björn Geldhof, Kathleen Glancy, Salima Hashmi, Asad Hayee, Paul Heredia, Zoe Jackman, Jill Jongen, Sharon Kent, Heather Kiernan, David Lally, Tatjana LeBoff, Margaret Liley, James Lingwood, Alice Lobb, Dev Mandal, Dale McFarland, Tina Marie Monelyon, Rahul More, Laura Montesanti, Czetan Patil, Siddhant Pitale, Estate of Irina Ratushinskaya, Maurizio Rigillo, Daisy Robinson-Smyth, Rajiv Saini, Sachin Salam, Prathamesh Sawant, Eve Scott, Sunil Shanbag, Santosh Shetty, Avinash Shingne, Sunny Sikka, Wole Soyinka, Miranda Stacey, Bruce Stracy, Peter Sutton, Dareen Tatour, Ankur Tewari, Alina Tiits, Pooja Tilve, Margherita Tinagli, Salil Tripathi, Parul Vadehra, Roshini Vadehra, Museum Voorlinden, Wassenaar (The Netherlands), Rory and Beinn Watson and Sara Whyatt.

This exhibition has been commissioned by the Barbican, London with support from Arts Council England and the Henry Moore Foundation.

Author Biographies

Urvashi Butalia is a publisher and writer based in India. In 1984 she co-founded Kali for Women, India's first feminist publishing house, and in 2003 became the director of its imprint Zubaan. She is the author of *The Other Side of Silence: Voices from the Partition of India* (1998), *Making a Difference: Feminist Publishing in the South* (with Ritu Menon, 1995) and *Mona: The Book of Sundays* (forthcoming, 2022). Butalia is the recipient of several international awards, including the Chevalier des Arts et des Lettres (2002), Padma Shri (2011) and the Goethe medal (2017).

Hilary Floe is Assistant Curator at the Barbican and has previously held curatorial positions at The Hepworth Wakefield and Modern Art Oxford. She holds a doctorate in History of Art from the University of Oxford and has contributed to numerous exhibitions and publications in the field of modern and contemporary art.

The sound installation, *For, In Your Tongue, I Cannot Fit*, 2017–18, was co-commissioned by YARAT Contemporary Art Space and Edinburgh Art Festival with support from PEN International.

The City of London Corporation is the founder and principal funder of the Barbican Centre

Supported using public funding by ARTS COUNCIL ENGLAND

The Curve Commissions